ANNE LABOVITZ

COMPOSITE PORTRAITS

Anne Labovitz Composite Portraits

ISBN 1-889523-38-0

Tweed Museum of Art
University of Minnesota Duluth
1201 Ordean Court
Duluth, MN 55812

218.726.8222
tma@d.umn.edu
www.d.umn.edu/tma

TWEED MUSEUM *of* ART

UNIVERSITY OF MINNESOTA DULUTH
Driven to Discover

The Tweed Museum of Art is one of six units in the School of Fine Arts, UMD.
The University of Minnesota is an equal opportunity educator and employer.

CLEAN WATER LAND & LEGACY AMENDMENT MINNESOTA STATE ARTS BOARD

Tweed Museum of Art is a fiscal year 2013 recipient of an operating support grant from the Minnesota State Arts Board. This activity is funded, in part, by the arts and cultural heritage fund as appropriated by the Minnesota State Legislature with money from the Legacy Amendment vote of the people of Minnesota on November 4, 2008.

Front Cover *Histories*, 48" x 36", woodcut with acrylic with pastel on canvas, 2013

Texts

Curatorial Statement | Ken Bloom

Knowing that a tradition of portraiture exists within the mood and mode of the museum imbues an exhibition of portraits with an aura of formality not necessarily intended by the artist. From the standpoint of the Museum, an exhibition of portraiture fulfills the need to recognize difference in the form, and to read the collected set as a reference to artistic achievement. The portraits of this exhibition should also speak in part to the intensive studio effort by the artist, as well as to the sense of individuality for each subject. More problematic is that the truth of any of the paintings refers as much to the subjectiovity of the artist as to that of the viewer.

Portraiture is magnetic. The representation of a face compels our attention. Extraordinary portraiture invites interpretive reflection. Since facial recognition is so much a component of human communication, as is the recognition of facial expression, we imagine seeing a face in almost anything, from clouds to cookies. As a subject for art, the range of facial structures and the nuances of muscular expression are unlimited, as are the interpretive strategies that an artist may employ. We are long past the days when a portrait served as a replica of someone's visage. Then, the artist's opportunity to provide meaning was through having the figure conform to symbolic gestures, or to include meaningful objects. In today's form of painting the subject and artistic manner are inextricably linked, and our sense of the truth of the subject is conditioned by the character of the artwork itself. It is this complex combination of material, style and scale that informs and challenges us.

According to essayist Christina Chang, the portrait is a natural fit for Anne Labovitz' artistic project. Labovitz endeavors to reveal the human condition. Her commitment is to each and every single one of her portrait subjects, as well. Anne writes: "The driving force behind my work is energy and the human spirit: intricacies, subtleties, internal pieces of ourselves. My artistic process assists me in this search to discover and connect with others."

The truth of the multi-level exchange between subject and artist, and between viewer and portrait becomes emotionally charged and highly subjective, presenting itself as an invitation to engage, as well as to shock. To interpret another's experience is to pass through a mirror of oneself. This is the territory in which Anne Labovitz is working.

The artist asserts that the project is essentially an interrogation of identity according to how the artist feels while entranced by the act of seeing, and then subsequently representing those impressions according to lines, textures, and colors applied or removed in layers over surfaces of character features. Its product is intended to represent the identity of the other, as the artist understands the code of content. How are we to understand this code? To appreciate the intent of these works is to feel the artist's effort as an expression of desire and exorcism of archetypal binds to family. Its result is a linked process of action and imagination, wherein the identity of one is calculated in relation to another, yet defines the identity of the one as a reflective pastiche, where the one is made of the many.

The exhibition seeks to demonstrate an evolution in portraiture, the style and unique character of this one artist's achievement, and to allow the audience the opportunity to engage with a challenging artistic practice. There is an essential contest of ideas posed to both artist and audience. That is, to consider the veracity of representation in so far as the subjectivity of the work is exaggerated by the combined material process and perceptual intent of the artist, the role of painting as a vehicle for transmission of meaning, and the opportunity to engage in an innermost question of how identity is constructed.

The Portrait Within | Christina Chang

The portrait is one of the oldest genres in the history of art. On the face of it, the portrait seems self-evident as an object. The artist is presumably charged with the "simple" task of rendering a likeness of the subject. The greatest portraitists were not, however, revered and sought out by wealthy patrons simply because they were skilled at creating accurate representations. The portraits of nineteenth-century French master Jean-Auguste-Dominique Ingres, for example, display a signature style that have less to do with correct proportions and more to do with conveying aristocratic comportment and the richness of the portrait sitter's domain. Despite Ingres' success as a portraitist, he endeavored to be remembered for his history paintings—large-scale ambitious works of civic import—rather than for works that were explicitly tied to private patronage. His ambivalence towards portraiture was shared by many other great portraitists. It was seen as a way to make a living while the artist pursued loftier ambitions.

As modernism loosened the link between the subject and its image or representation, artists took greater creative license with their portraits. Focus turned to less tangible, harder to define qualities of their subject—an essence, so to speak. A painted portrait in the age of photography is a statement about the sitter's values and, perhaps, her aspirations. The statement-making applies in reverse as well. Anne Labovitz is staking a claim on a somewhat unfashionable genre. In this, Anne's work strongly brings to mind the portraits of Alice Neel, another artist whose work defied prevailing trends of her time (the conceptual turn of the 1970s) to pursue a singular vision and find critical success in the unlikeliest of places, the figurative tradition.

I do not mean to suggest that Anne's commitment to portraiture is the result of a calculated strategy. Rather, as this essay will demonstrate, the portrait is a natural fit for Anne's artistic project, which endeavors to connect with the human condition. Thus, her commitment is to each and every single one of her portrait subjects as well. As she writes in her artist statement, "The driving force behind my work is energy and the human spirit: intricacies, subtleties, internal pieces of ourselves. My artistic process assists me in this search to discover and connect with others." Indeed, what she herself describes as a "laborious" artistic process is the key to understanding the new directions that she is taking portraiture.

Before we delve deeper into the specific technical innovations that each of the portraits in this exhibition employ, it must be stated that Anne's work has undergone a rapid and significant shift in the last several years. One could argue that this was a direct result of her time in Germany, where she lived with her family from 2005 to 2008. Anne would not be the first American artist to return from Europe transformed. While Anne's time in Germany was a significant life event, I do not mean to suggest that it holds the key to understanding her work. That said, Anne's paintings are always autobiographical to some degree. Like everyone else, she is an individual living her life as a daughter, mother, sister, student, mentor, friend, colleague, artist, collaborator—and the multitude of other roles she fills. An essential force in her art-making is the influence of interdependency as a point of reference and compassionate guide. As such, much of her practice has focused on those closest to her, at once the most forgiving and the most difficult subjects.

Anne Labovitz: Composite Portraits at the Tweed Museum of Art (June 4 – August 11, 2013), is a carefully curated snapshot of Anne's portrait practice by Director Ken Bloom. They are also snapshots of Anne's own family and closest friends. She remains captivated by her search to capture and represent her most complex relationships in a single canvas, and has often turned her gaze on herself. No doubt she has also inserted images of herself into portraits of family members, such as the one of her mother. How could a daughter not be present in her mother's image? Of all of the portraits in the show, the one of Anne's mother is the least legible. As a daughter myself, I wonder what this says about the relationship and the connection. Of course, it's not because Anne doesn't know what her mother looks like, but perhaps the depth of feeling she has for her mother resists being represented clearly and rationally. This is an emotionally charged portrait.

Not everyone will be familiar with the subjects, so it might be helpful to think in more general, less personal terms. Another way for a viewer to approach Anne's portraits is to see them as metaphors for the construction of self and the exploration of identity. Each portrait in this exhibition begins with a photograph or memory, which serves as the basis for a woodcut. Anne sketches the portrait on a thin slab of wood. The areas that are to be blank in the printed image are carved away, and the remaining raised

areas of the wood surface will leave an imprint when inked. An individual portrait may contain up to 100 overlapping imprints accumulated over the course of several months. Each "session" with the subject, which sometimes takes the form of drawing, is sealed in polymer emulsion.

The labor required to print the number of impressions that goes into each finished work is compounded by the fact that printing is, quite simply, hard work. A wall of her studio is rigged with a pulley system that allows her to lower a large 8' x 8' canvas without assistance to the floor, and raise it again back up. She uses the weight of her own body to print, pressing the backside of the canvas against the woodcut lying face up on the floor. In the continual handling of these canvases, each layer is sealed with polymer emulsion before making the next impression, or adding the next layer of drawing. This preserves and fossilizes each step. In this sense, the artist's process is profoundly physical and provides Anne with a tangible relation to each portrait as an object in ways that go past the mere visual aspect of the work. This connects the artist with the portraits in a way that the gallery viewer might consider more as a talisman than formal portrait.

The preservation of each layer is absolutely crucial to the work, for it enables the portrait to exist both as a composite image and a metaphor for the construction of self over time and experience. Each semi-transparent layer records a moment not only in Anne's process – time – but also her fond recollection of the subject – memory. "My search," she explains, involves "processing and reprocessing," and resolves when she finally "connects" with her subject. Her process demonstrates in a literal and tangible way the fact that the self emerges through different stages, or layers, of one's life. More bluntly, they are reminders that all versions of yourself, even the less flattering ones, make up who you are today. This total and complete acceptance of the multi-dimensionality of human beings is a product of the empathy Anne has and feels for her subjects. Her desire to capture and convey their multi-dimensionality on a resolutely two-dimensional surface has given rise to a unique process. As the saying goes, necessity is the mother of invention.

Christina Chang holds a PhD in art history from the University of Michigan (2010). She served as Assistant Curator at the Weisman Art Museum at the University of Minnesota until June 2012 and serves on the Board of Directors of Photography @ the Center. She is currently Curator of Engagement at the Minnesota Museum of American Art and is charged with embedding the museum into the cultural life of St. Paul and the Twin Cities through active dialogue with artists and organizations.

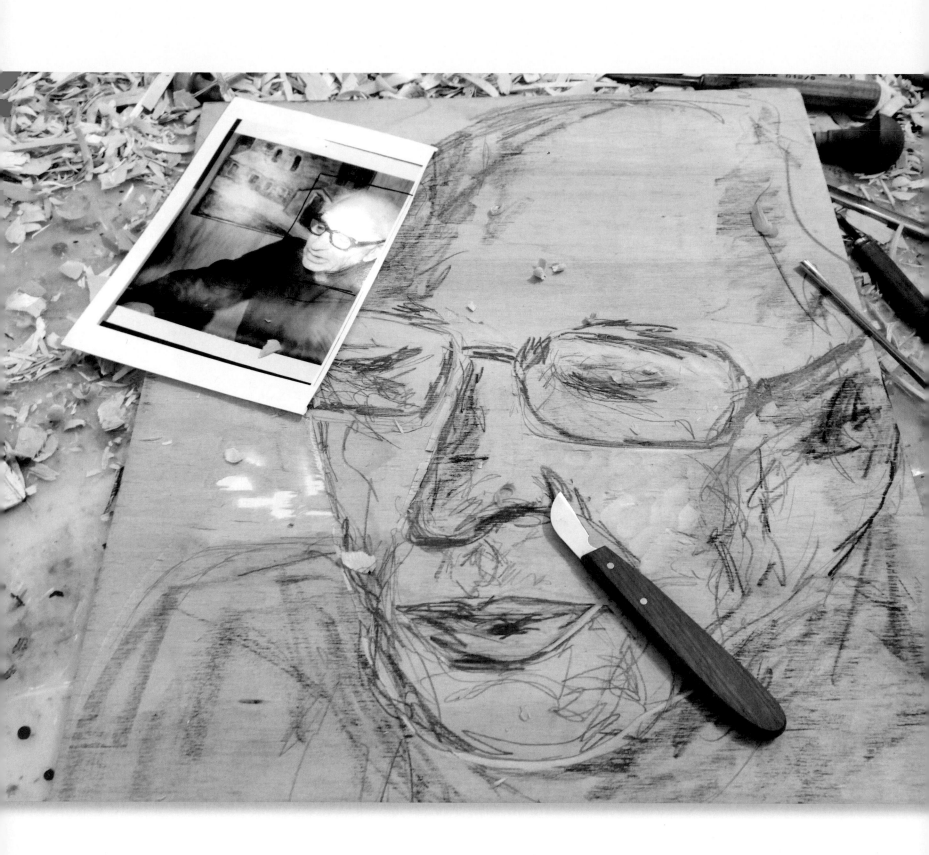

Artist Statement | Anne Labovitz

The driving force behind my work is an enduring interest in people; in the human spirit, its emotional resonance and the way it manifests in our relationships with others.

Throughout my career as an artist I have been heavily influenced by the German Expressionists, in particular Ernst Ludwig Kirchner. I have been profoundly moved by the early woodcuts of Max Beckmann and I actively seek to preserve the same kind of powerful and dynamic marks in my own woodblocks by use of grades of wood prone to breaking out and splintering. I seek raw dynamic qualities as a metaphor for the base, unbridled and instinctual aspects of our being.

My portrait work combines woodcut impressions hovering between layers of painting and drawings. It assimilates the multifaceted experiences of a person's life – communicating its intricacies, subtleties and internal fragments

These portraits are composites. Each piece is comprised of multiple subjects or family members as representations of the complex composition of identity. The artworks demonstrate how, layered by a confluence of experiences, character and personality become one's persona. I am compelled to embed and surround the face with a collection of symbolic details. I accomplish this by adding and reducing visual components, which obscures conventionally descriptive depictions. The overlapping and ghosting of the layers eventually creates an amalgam. These complex portraits – with imagery sometimes visible, sometimes masked – develop over months in a way similar to how we grow and change as humans.

I am drawn to multilayered works because each stratum indicates fragments of identity. They are more than mere representations of identity, in my mind they exist as the layers of one's persona Just as significant moments in one's life build our character and shape us, so too, do the layers I apply to each piece. In this way – working across multiple pieces at any one time, intentionally applying layers – what lies beneath is often subdued. I am compelled to what might be revealed and obscured by this approach, and am more interested in building my people rather than crafting them. The process begins with daily photo-documentation of my subjects on the assumption that using multiple photos provides an aspect of time continuum comprised of

emotion, reaction, and dialogue. Then I replace the photographs by drawing from them. The drawings then become a memorial record.

This transformation of photographic depiction to line is applied to many kinds of surfaces, using any number of media. For this body of work in particular, I also employ my drawing with woodblock techniques. Each piece is comprised of individuals whose drawings are carved in wood for relief printing. Sometimes, a single face spans several boards, allowing it to be separated and printed in fragments. My works develop through layer after layer of drawing and printing from the woodcuts of each family member. Thin layers of acrylic polymer emulsion are used in between these layers to fossilize the marks made with ink and pastels. By using this layering technique the surface builds in depth and transparency simultaneously.

In the last year, I have added the dimension of video to my studio practice, collaborating on two films and employing the use of motion-sensor cameras to document my artistic process. Presently, I replay audio recordings of conversations with individuals and families while painting to increase my understanding and connection to that person. I am interested in broadening the use of media to highlight my main focus – to engage and participate in a conversation about who we are as individuals, and as members of families and of our communities.

Artist Biography | Anne Labovitz

Anne Labovitz is a full-time practicing, professional artist who lives and works in St. Paul, MN. Exhibited within and outside the U.S., Anne has international gallery and museum representation including galleries in Spain and Germany. Her paintings are part of the permanent collections at the Tweed Museum of Art in Duluth, MN, the Athenaeum Music & Arts Library in La Jolla, CA and the International Gallery of Portrait in Bosnia-Herzegovina. Additionally, she is frequently commissioned and has paintings both abroad and in the U.S. in hotels, hospitals, banks, salons and private corporations.

Anne graduated with a degree in art and art education from Hamline University in St. Paul, MN with honors. She has trained in studios in Italy, Santa Fe, New York, Massachusetts and North Carolina. Her passion for art education both in schools and in the community keeps her teaching within both public and private schools and offering workshops to artists of all ages around the Twin Cities. She is active in the art community in the metro area and is both a member of the Board of Trustees for the Walker Art Center and the Colleagues Advisory Board at the Weisman Art Museum on the campus of the University of Minnesota.

Both Anne's portraits and landscape pieces have been published in *Studio Visit Magazine, Vol. 19*, *New American Paintings Midwest 2010*, the *Penang International Printmaking Exhibition 2010* and *International Contemporary Artists, vol II and III*. She has co-authored several books on portraiture with Australian artist, Carole Best, and provided illustrations for the children's book, *Honoral & Zarina*. Additionally, her artwork was selected to be the cover art for two books and the program cover at the Athenaeum Music & Arts Library in La Jolla, California for their 2011-2012 music season. Her artwork has been written about in the *Chicago Sun Times*, the *Duluth Tribune* and the *Taos Review* amongst others.

Artwork

Lineage

2013

8' x 8'

WOODCUT WITH ACRYLIC AND
PASTEL ON CANVAS

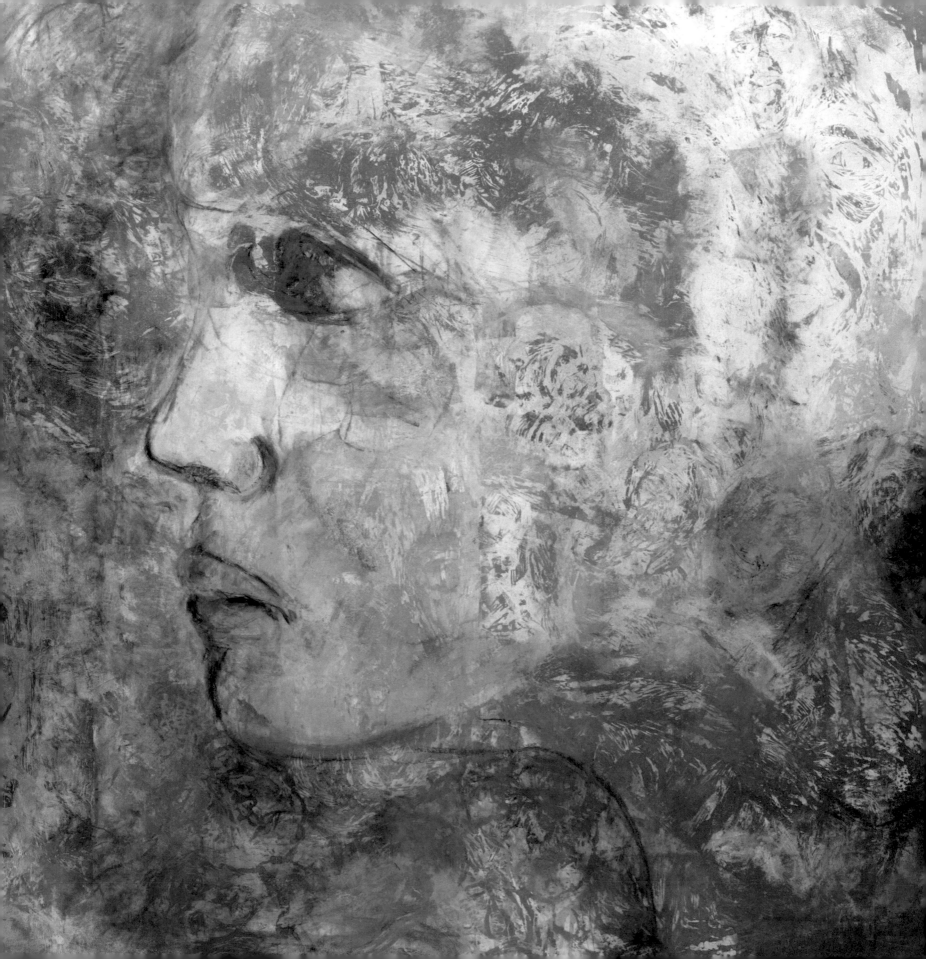

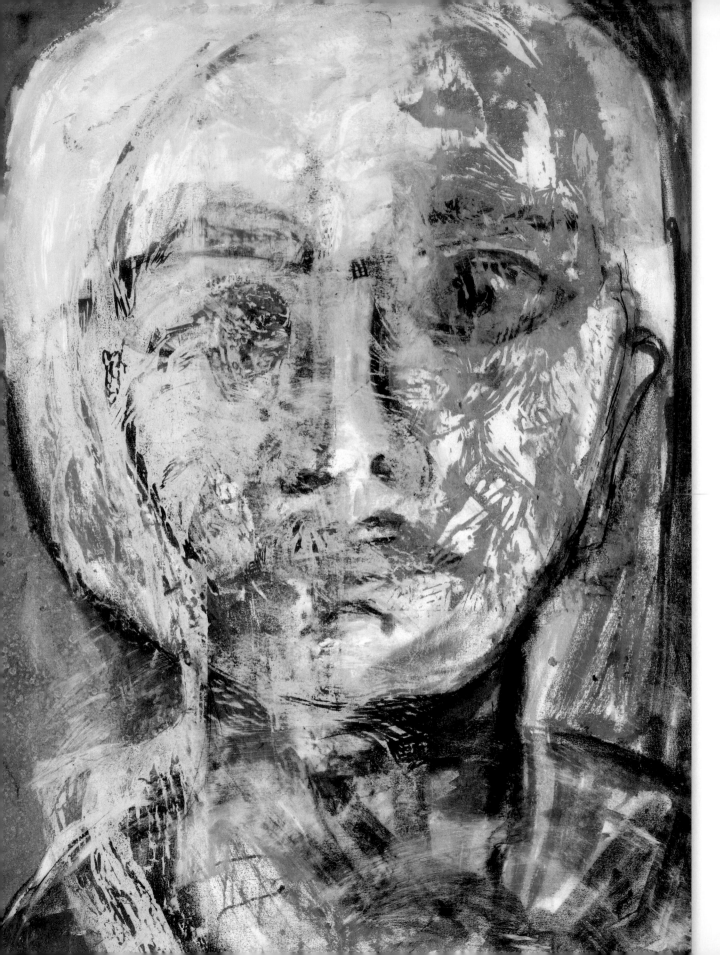

Bronze

2012
48" x 36"
WOODCUT WITH ACRYLIC AND
PASTEL ON CANVAS

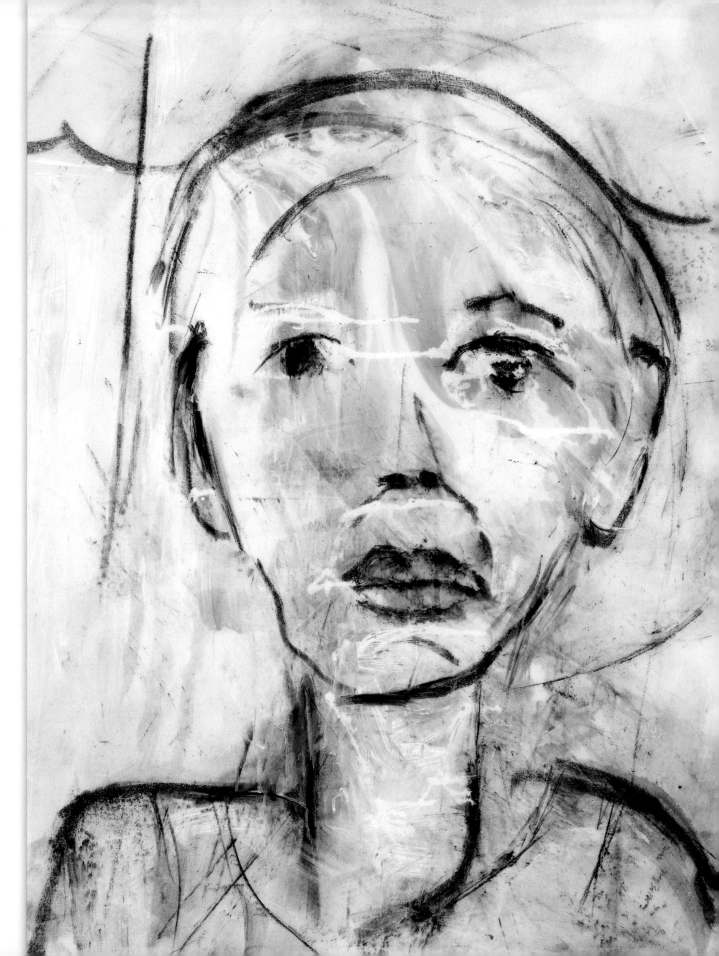

White
2012
48" x 36"
ACRYLIC AND PASTEL ON CANVAS

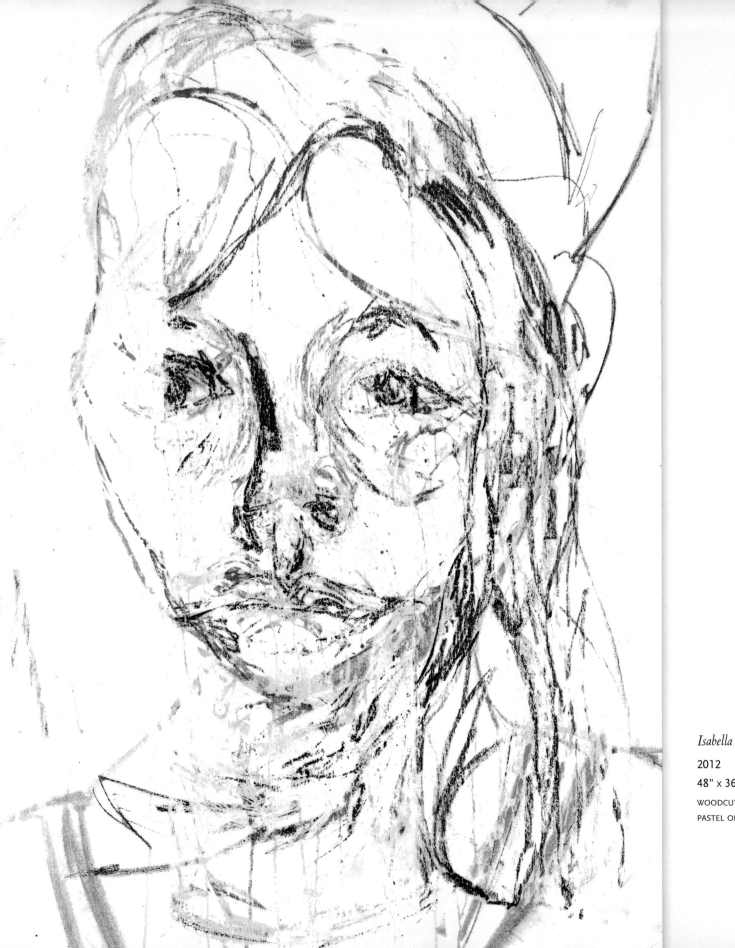

Isabella

2012

48" x 36"

WOODCUT WITH ACRYLIC AND
PASTEL ON CANVAS

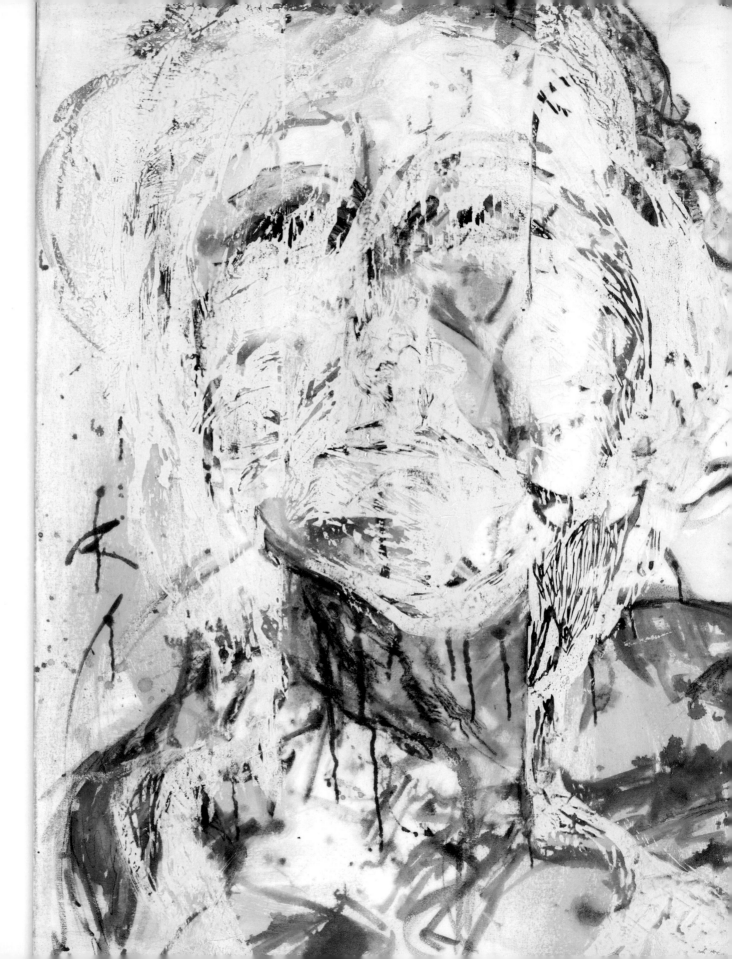

Mother

2012

48" x 36"

WOODCUT WITH ACRYLIC AND
PASTEL ON CANVAS

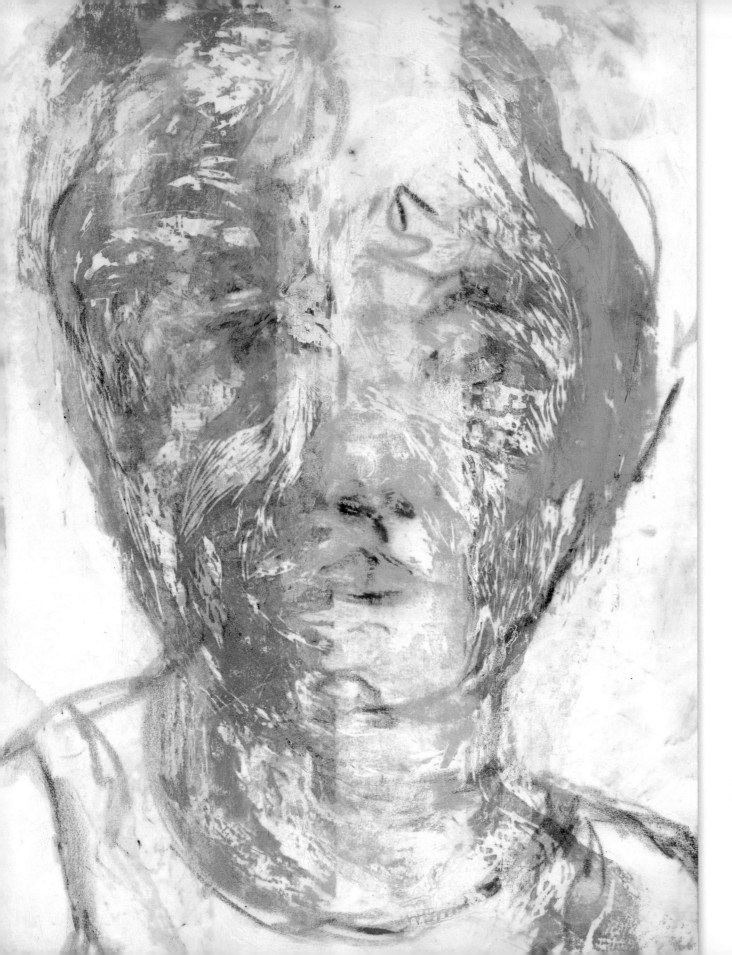

Three

2012

48" x 36"

WOODCUT WITH ACRYLIC AND
PASTEL ON CANVAS

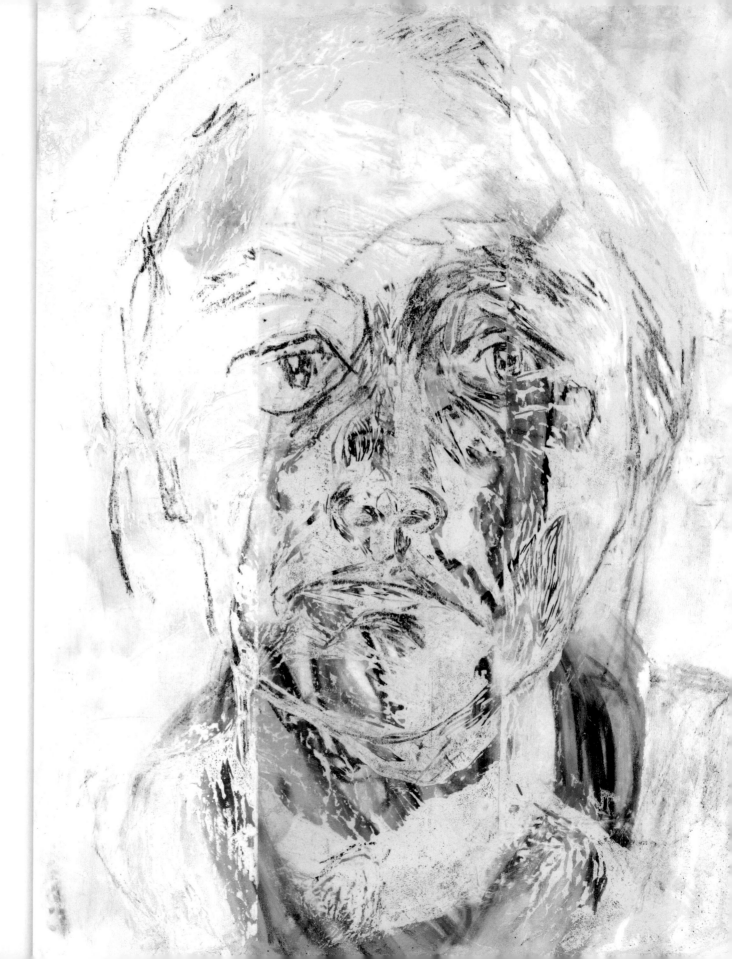

Native

2012

48" x 36"

WOODCUT WITH ACRYLIC AND
PASTEL ON CANVAS

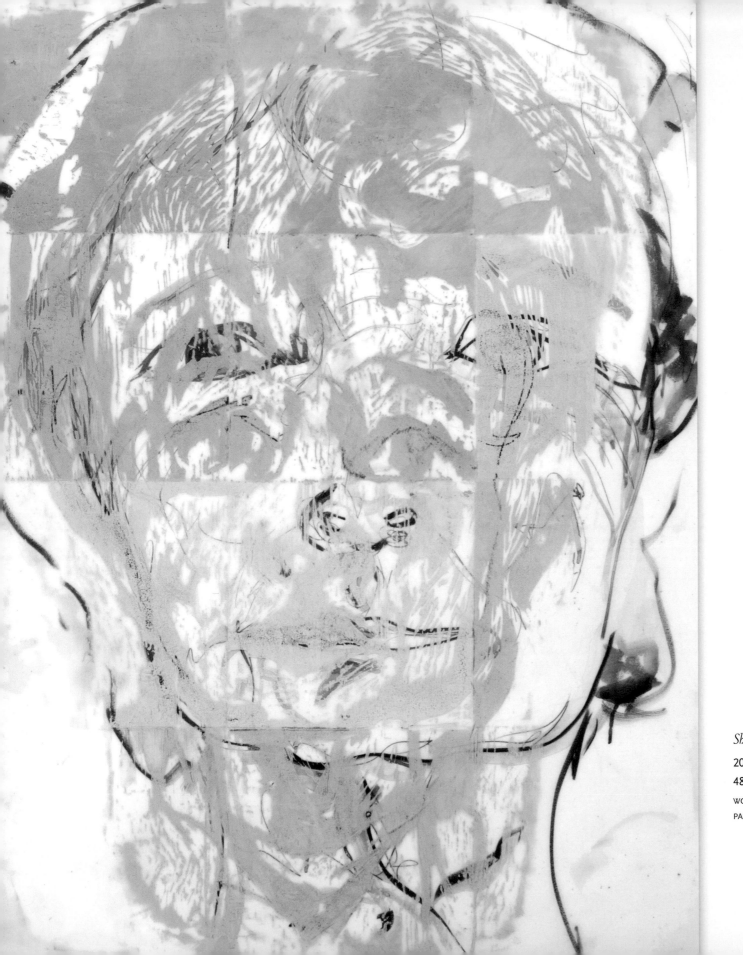

Sharon

2013
48" x 36"
WOODCUT WITH ACRYLIC AND
PASTEL ON CANVAS

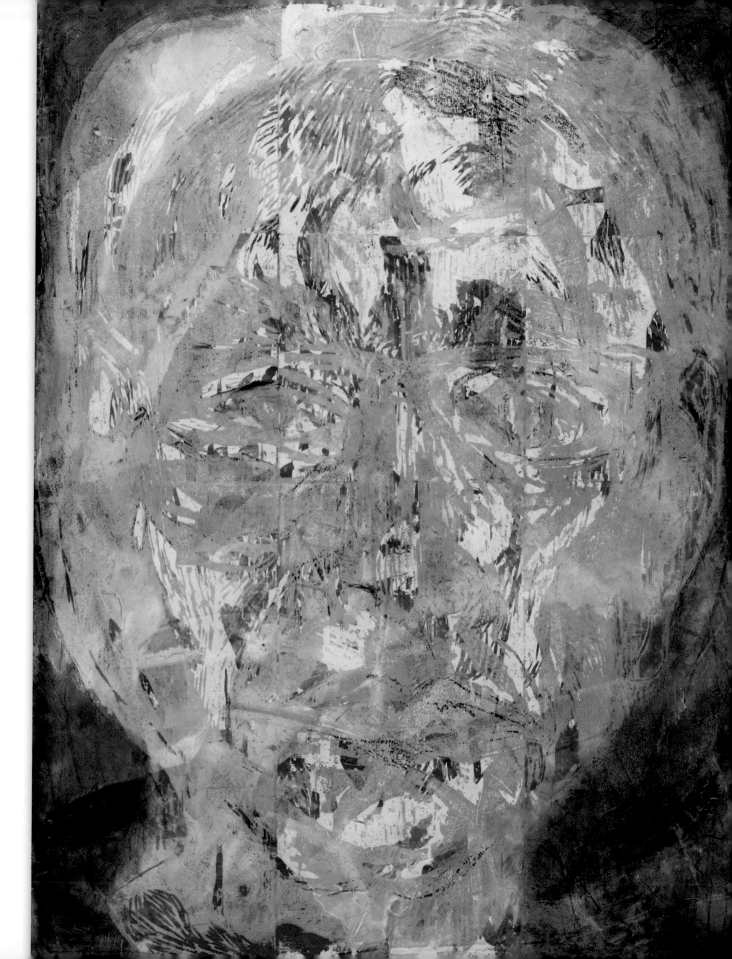

Red Head

2013

48" x 36"

WOODCUT WITH ACRYLIC AND
PASTEL ON CANVAS

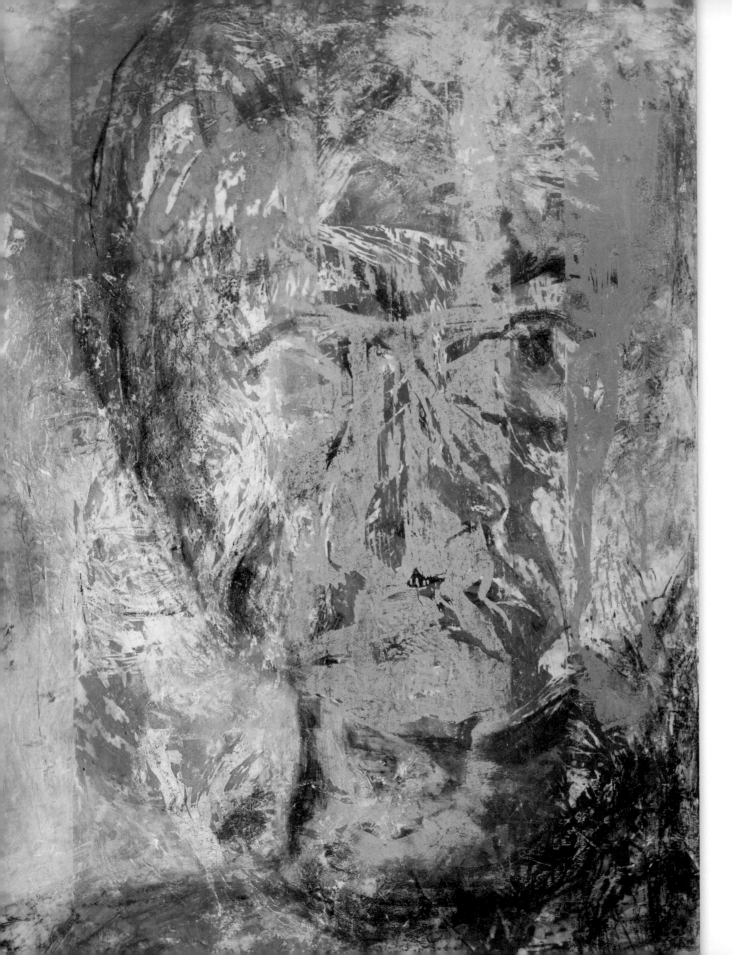

Untitled 11 (Earth Tones)

2013

48" x 36"

WOODCUT WITH ACRYLIC AND
PASTEL ON CANVAS

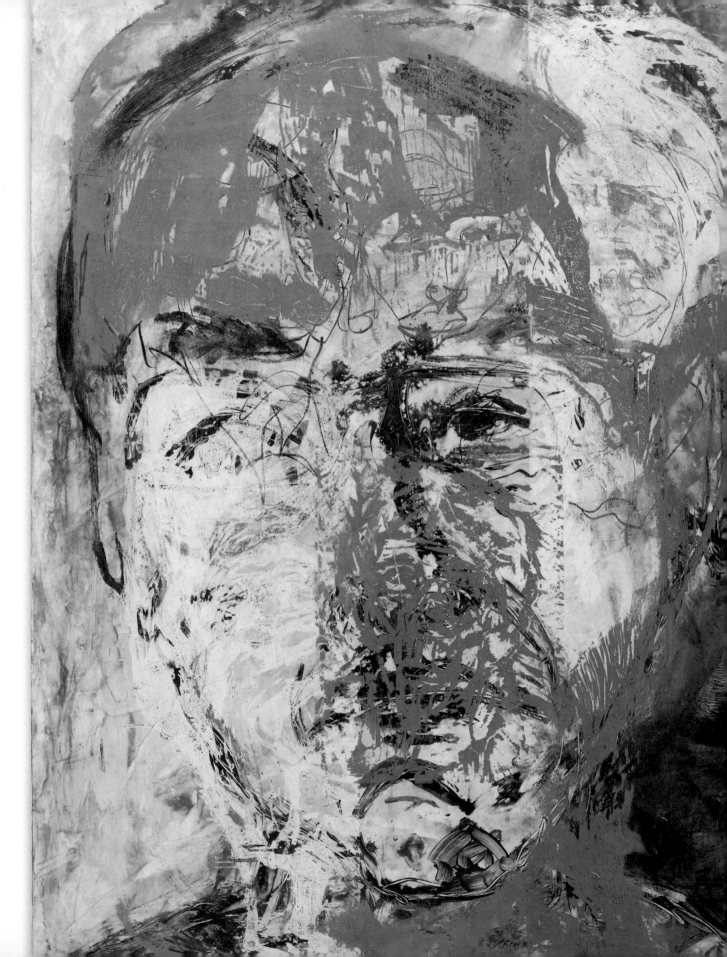

Couple in Yellow

2013

48" x 36"

WOODCUT WITH ACRYLIC AND
PASTEL ON CANVAS

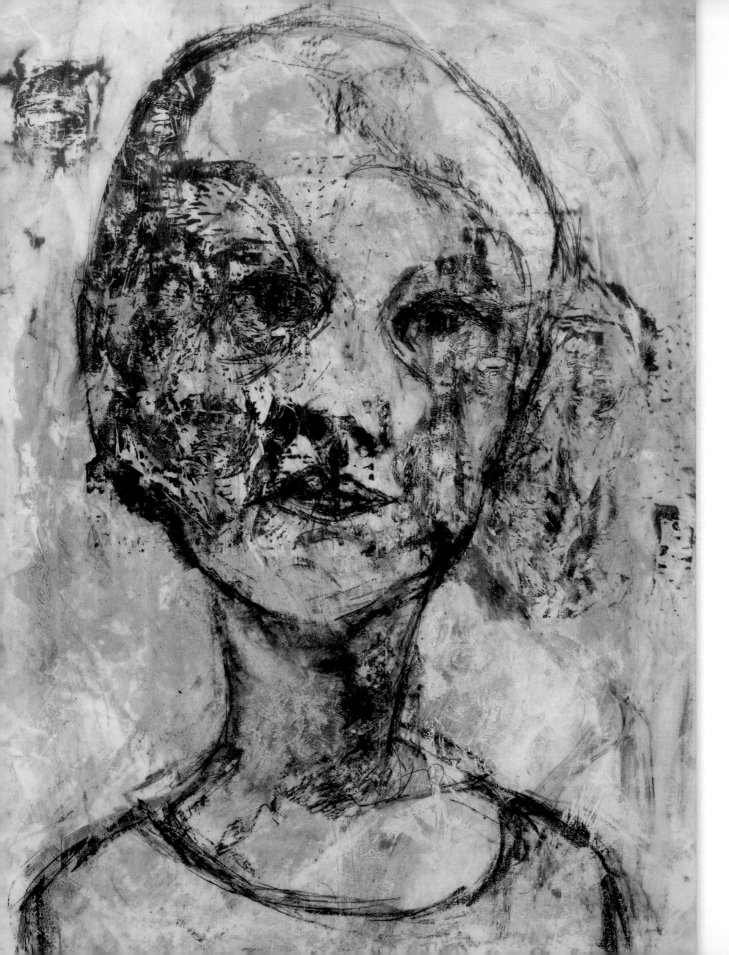

Young Boy

2013

40" x 30"

WOODCUT WITH ACRYLIC AND
PASTEL ON CANVAS

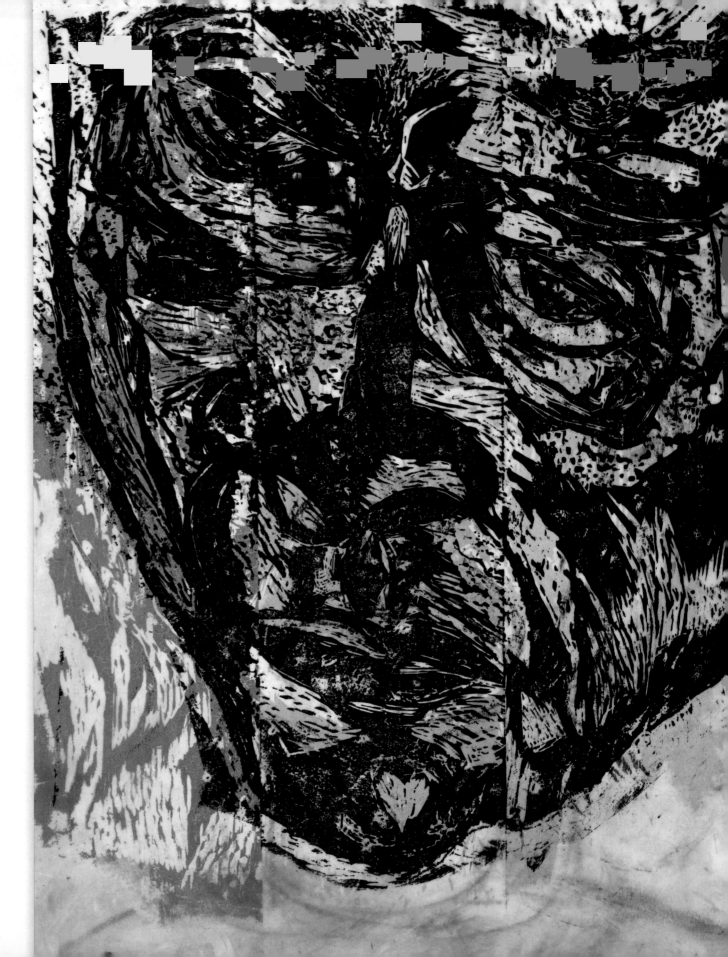

Untitled 14 (Black)

2013

48" x 36"

WOODCUT WITH ACRYLIC AND
PASTEL ON CANVAS

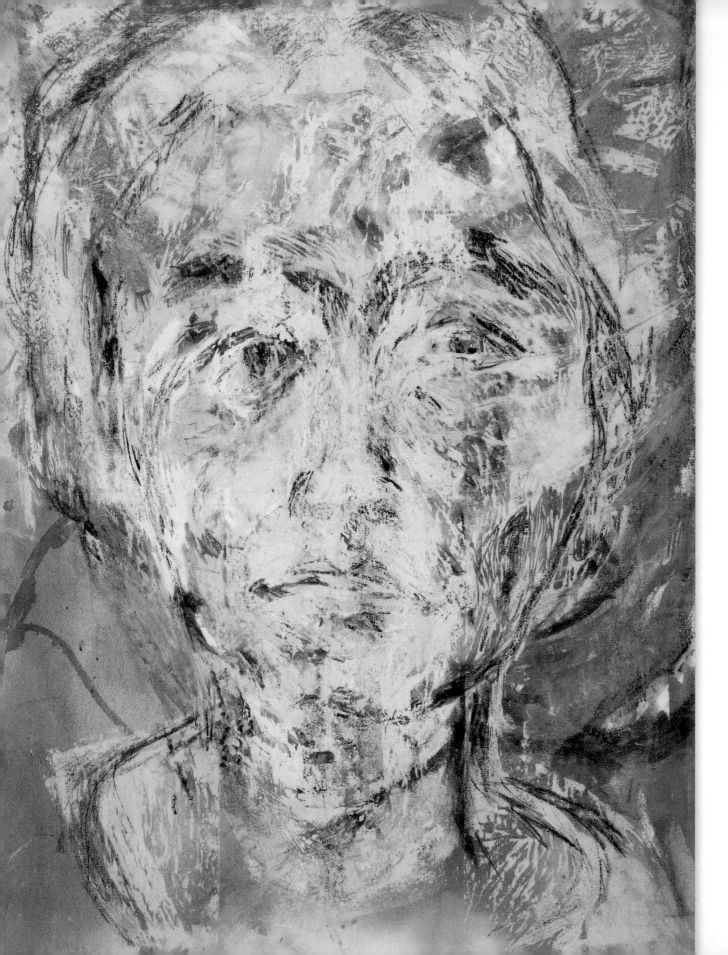

Untitled 12 (Female with Grey)

2013

48" x 36"

WOODCUT WITH ACRYLIC AND
PASTEL ON CANVAS

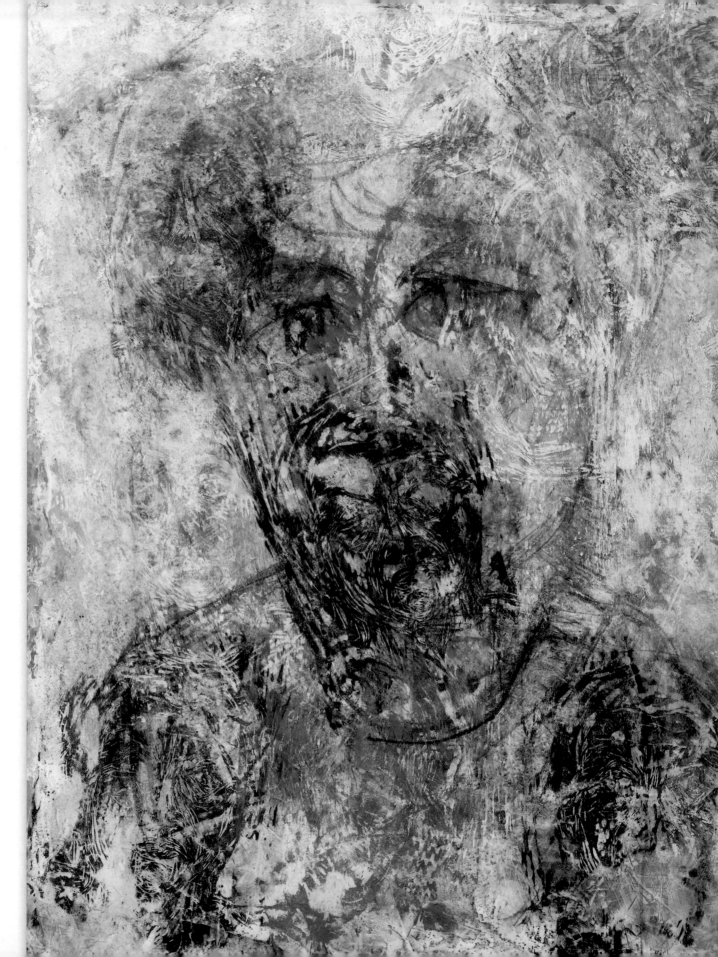

Histories

2013
48" x 36"

WOODCUT WITH ACRYLIC AND
PASTEL ON CANVAS

Index

Staff & Administration

University of Minnesota Duluth Administration

Lendley (Lynn) C. Black, *Chancellor*

Lisa Erwin, *Vice Chancellor for Student Life*

Andrea Schokker, *Executive Vice Chancellor for Academic Affairs*

Michael P Seymour, *Vice Chancellor for Finance & Operations*

Lucy Kragness, *Chief of Staff to Chancellor*

William E. Payne, *Dean School of Fine Arts*

Tweed Museum of Art Advisory Board

Mike Seyfer, *President*

Matthew Wehber, *Student Representative*

Sada Brickson

Alice O'Connor

Bruce Hansen

Tiegen Fryberger

Joseph Leek

Tracy Link

Peggy Mason

Suzanne McKinney

Terry Roberts

Dan Shogren

Miriam Sommerness

DeeDee Widdes

Lee Ziegler

Director's Circle

Florence Collins

Barbara Gaddie

Beverly Goldfine

Bea Levey

Robin Seiler

Tweed Museum of Art Staff

Ken Bloom, *Director*

Barbara Boo, *Museum Store Manager*

Camille Doran, *Registrar*

Eric Dubnicka, *Preparator*

Susan Hudec, *Museum Educator*

Steve Johnson, *Guard*

Kathy Sandstedt, *Comptroller*

Joan Slack, *Curator of Programs*

Scott Stevens, *Head Security*

Christine Strom, *Communications Coordinator*

Greg Tiburzi, *Guard*

Leta Waterfall, *Guard*

Student Staff

Anna Anderson, *Office/Business Assistant*

Shawnee Harkness, *Registrarial Assistant*

Jennifer Hildebrandt, *Museum Store*

Andrew Kilness, *Graphic Design*

Laura Messner, *Museum Store*

Hannah Nguyen, *Registrarial Assistant*

Amy Nguyen, *Registrarial Assistant*

Karley Nyhus, *Graphic Design*

Elaine Terry, *Museum Store*

Logan West, *Graphic Design*

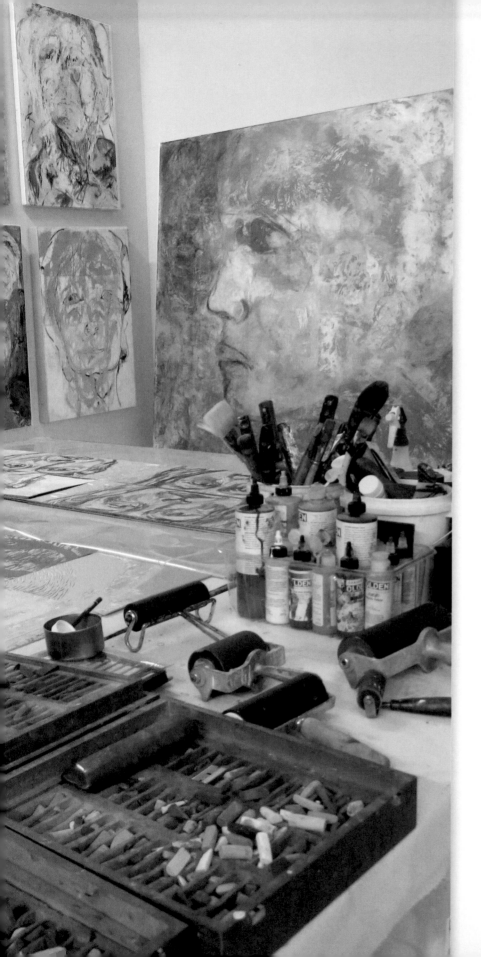

Acknowledgements

Photography Gene Pittman
Catalogue Design Catherine Meier

This publication is funded in part by Holiday Inn & Suites Duluth, MN, Maurices, Nash Frame Design, Otis-Magie Insurance Agency, Security Jewelers, and The Edge Pilates Studio.

Artist Resumé

Education

1989 Art and Art Education, Hamline University

Selected Solo Exhibitions

2013 Tweed Museum of Art, Duluth, MN, June

 Charles Harris Library Gallery, Wise, VA, September

2010 Athenaeum Music & Arts Library, Passions, La Jolla, CA

2009 Anne Labovitz Journey, Lizzards Art Gallery concurrent with North Shore Bank, Duluth, MN

 El Refor, Bilbao, Spain

2002–06 Fine Arts Gallery, Arkansas State University, St. University, AK

2002 Chapman Art Center Gallery, Cazenovia College, Cazenovia, NY

 Talgut die Schönen, Künste, Germany

 Hot off the Press, Steve Powell Gallery, Taos, NM

1998 Innovative Inspirations, Lizzards II, Duluth, MN

1996 New Monotypes, Lizzards I, Duluth, MN

1994 Dakota Fine Arts, Fargo, ND

1993 The Corn Maiden, Blue Moon, Taos, NM

 Light Bearers, Gallery 323, Duluth, MN

1992 Shadows of my Former Self, Open Concepts Gallery, Duluth, MN

Selected Group Exhibitions

2013 Selections from the Permanent Collection, Athenaeum Music & Arts Library, La Jolla, CA

 St. Croix Art Reach, St. Croix, MN

2012 Recent Acquisitions, Athenaeum Music & Arts Library, La Jolla, CA

 Anima, Fibre Arts Design, Palo Alto, CA

 Women's Art Registry of Minnesota, Women's Building, St. Paul, MN

2011 Frailty, MN Coffman Gallery, University of Minnesota, Minneapolis, MN

 Journeys, Foss Gallery, Edina Art Center, Edina, MN

 INTERBIFEB XIV, Gallerija Portreta, Tuzla, Bosnia-Herzegovinia

2010 Emerging Artist, Morpho Gallery, Chicago, IL

 National Association of Women Artists, NY, NY

 The Green Show, Marnie Sheridan Gallery, Nashville, TN

 Water Street Studios, Batavia, IL

2006 Kunstverein Neustadt e.v.,Neustadt, Germany

2001 Art Resources Gallery, Minneapolis, St. Paul and Edina, MN

2002 T.W. Wood Gallery & Art Center, Vermont College, Montpellier, VT

2000 Great Expectations, Lizzards Art Gallery, Duluth, MN

 Dungeon Duo Show, St. Paul, MN

1995	Finley Gallery, Birmingham, AL
	Lizzards, Duluth, MN
	A Different Language, New Masters Fine Arts, Taos, NM
1994	Ella and Anne Labovitz, Duluth Art Institute, Duluth, MN
	Gallery 416, Minneapolis, MN
2000	Dungeon Duo, Cafe News, St. Paul, MN
1998	Sanata Reporta, Florence, Italy
1997	Mostra, Commune Centrale, Barga, Italy
	Taos Art Association, Taos, NM
1996	New Masters Fine Art, Taos, NM
1995	Dayton Visual Arts Center, Dayton, OH
	Works on Paper, New Masters Fine Art, Taos, NM

Collaborative Projects

2013	Minnesota Museum of Modern Art, First Friday Film Series, "Schale"
2012	Minnesota Museum of American Art, "Identities & Passions"
	Midway Contemporary Art, Participating Artist, Monster Drawing Rally
2010	A. Labovitz and C. Best, Dungeon Depths: Two Artists Explore the Self-Portrait
2009	A. Labovitz and C. Best, A Dozen Days in the Dungeon
	Gamble, Bill, Zarina and Honoral
2007	Labovitz and C. Best, Dwellings 2
2004	Champagne Art Book, A. Labovitz and C. Best
1999	Judith Triumphant Opera, Exmachina

Bibliography

2013	Studio Visit, Volume 19, Selections from the Permanent Collection, 1990-2010, Athenaeum Music & Arts Library
2012	International Contemporary Artists, Vol. III
2011	Women Today Magazine, Duluth, MN, "For the Love of Painting", December/January
	International Contemporary Artists, Vol. II
2010	La Jolla Light, "Anne Labovitz art exhibit at the Athenaeum is rich with Passions"
	November New American Paintings, Midwest Region
2002	Allaour Anzeigeblatt, "Warme Farborgien", Germany, July 4
	Times Argus, "Every Which Way", Barre, VT, April 12
	Seven Days, "Three's Company", Burlington, VT, April 10
1997	"La Jolla Light", La Jolla, CA, April 10
1996	Duluth News-Tribune, "Profile", Duluth, MN, June
1995	Duluth News-Tribune, "Review", Duluth, MN, Nov. 2
	Duluth Zenith City Pages, Duluth, MN, July

1995	Taos News, "Review", Taos, NM, Dec. 28
1994	Ella and Anne Labovitz, "Exhibition Catalog", Duluth Art Institute, Duluth, MN, Sept.
	Depot Quarterly, Duluth, MN, Fall
1992	Alexandria Museum of Art Annual, Alexandria, LA, Sept.
	Minnesota Public Radio, "Interview", Minneapolis, MN, August 28
	Duluth News-Tribune, Duluth, MN, August 28
	Duluth Zenith City Pages, "Review of Solo Exhibition", Duluth, MN, September
	Chicago Sun-Times, "Review of Good Press Exhibition", Chicago, IL, February 7

Affiliations

2011–present	Board of Trustees, Walker Art Center, Minneapolis, MN
2009–present	Colleagues Advisory Board, Weisman Art Museum, Minneapolis, MN

Gallery Representation

Kunstverein Neustadt e.v., Neustadt, Germany

Taos Tin Works, Taos, NM

Hudson Gallery, Sylvania, OH

Lizzards, Duluth, MN

Collections

Art Domain Leipzig

Baviera International, Minneapolis, MN

Baviera International, Stockholm, Sweden

Burr and Forman, Birmingham, AL

Colonial Hotel, La Jolla, CA

Courtyard Marriot, Waco, TX

Duluth Housing Authority, Duluth, MN

Duluth Women's Building, Duluth, MN

Effecta Communication, Sollentuna, Sweden

Fryberger, Buchanan, Smith and Frederick,
 P.A., Duluth, MN

Hilton Garden Inn, Palm Coast, Florida

Holiday Inn Hotel and Suites, Duluth, MN

Holy Cross Hospital, Taos, NM

Hyer-Reissner, Hannover, Germany

Juut Salonspa, Minneapolis, MN

Missabe Building, Duluth, MN

Penang International Printmaking Exhibition 2010

Piper Jaffray, Fargo, ND

Spezialarzt fur Innere Medizin FMH,
 Basil, Sweden

Dr. Hugo Steiner, Basel, Switzerland

Tweed Museum of Art, Univ. of MN, Duluth, MN

Union State Bank, Fargo, ND

Wells Fargo, Duluth, MN

Zenith Management, Duluth, MN

El Refor, Bilbao, Spain

Dr. Klaus Goeschen, Hannover, Germany

Adecvate Consult AB, Stockholm, Sweden

Studio Camnitzer, Lucca, Italy